DRA` D0756566 500FABULOUS FASHIONS

A Sketchbook for Artists, Designers, and Doodlers

JULIA KUO

Quarry Books 100 Cummings Center, Suite 406L Beverly, MA 01915

quarrybooks.com • craftside.typepad.com

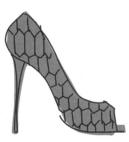

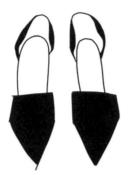

HOW TO USE THIS BOOK

This book features 500 drawings of all sorts of fantastic fashions from cocktail dresses and cardigans to T-shirts and totes. You will see that most of these drawings are comprised of simple combinations of lines and shapes. When you look at a garment you want to draw, what do you see? Are there squares, circles, or triangles? Are the outlines of the shape straight, curved, or wiggly? When drawing fashion, look for the big shapes and lines first, and then add in the smaller details.

Use the illustrations in this book as inspiration. You can trace them, copy them, or change the details to draw your own versions. There's plenty of blank space to draw right in the book, so grab a pencil, pen, marker, or brush, and have fun drawing 500 more apparel items of your own!

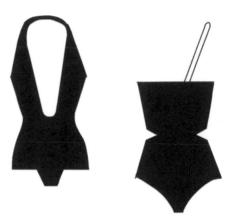

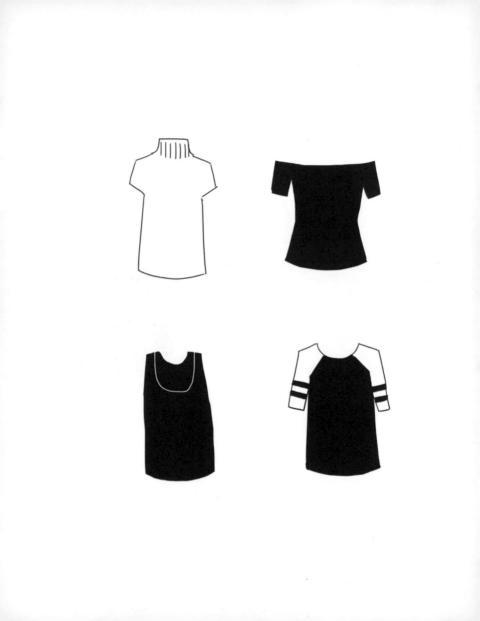

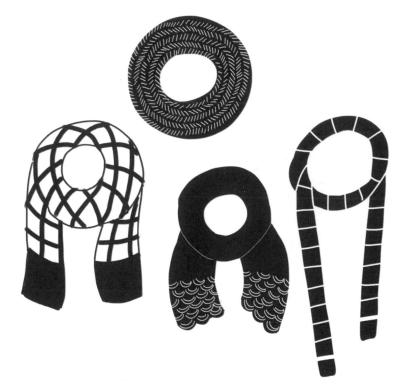

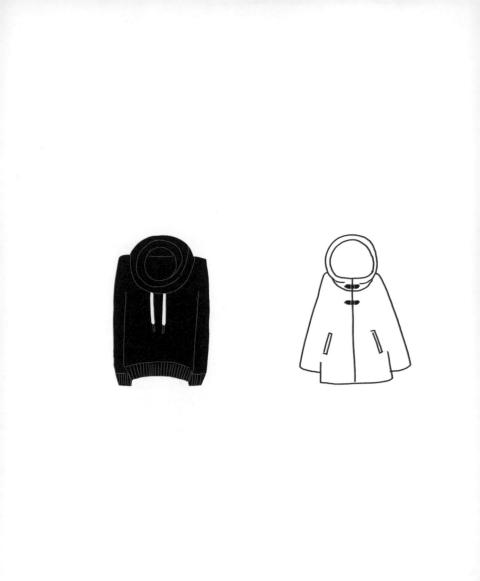

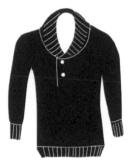

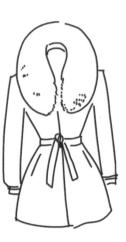

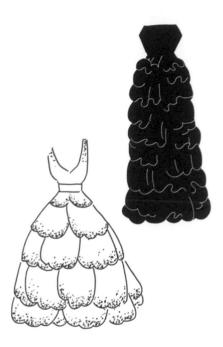

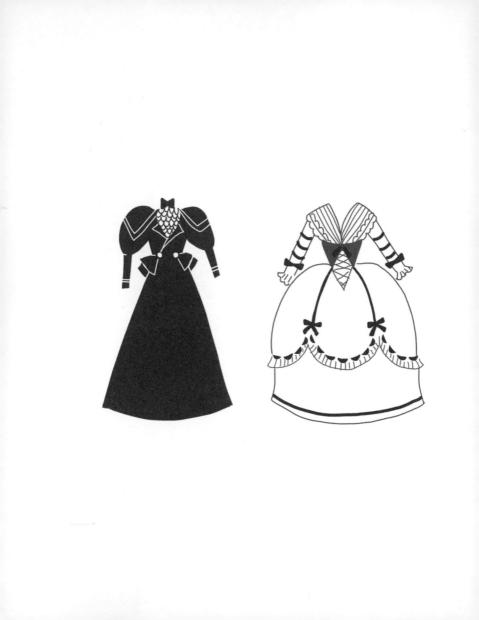

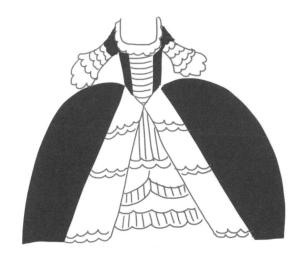

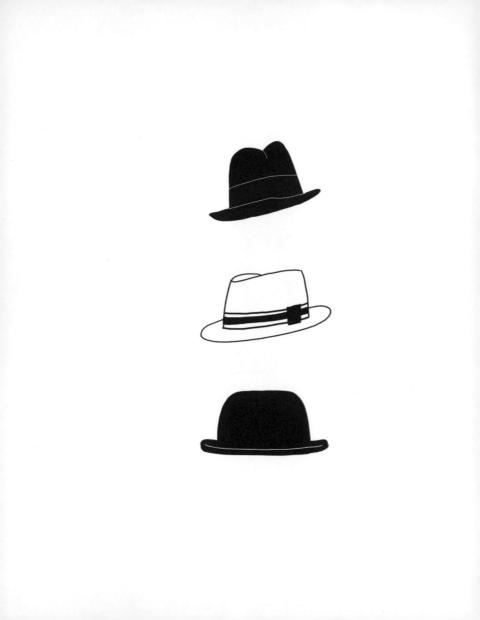

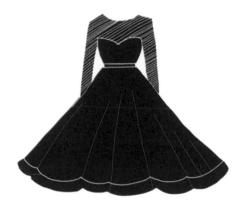

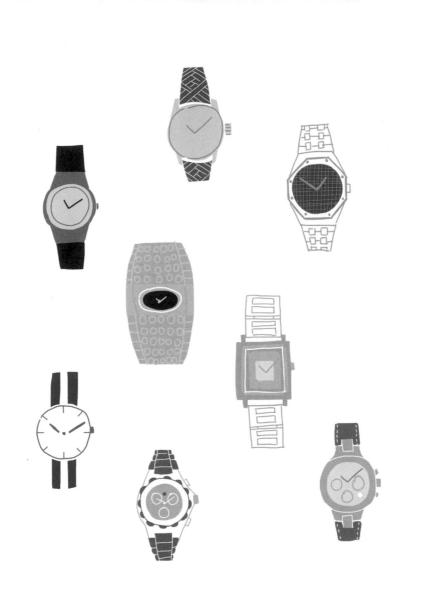

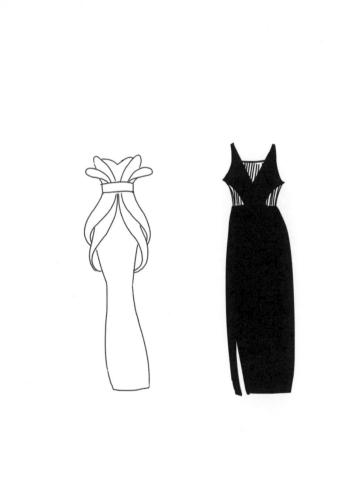

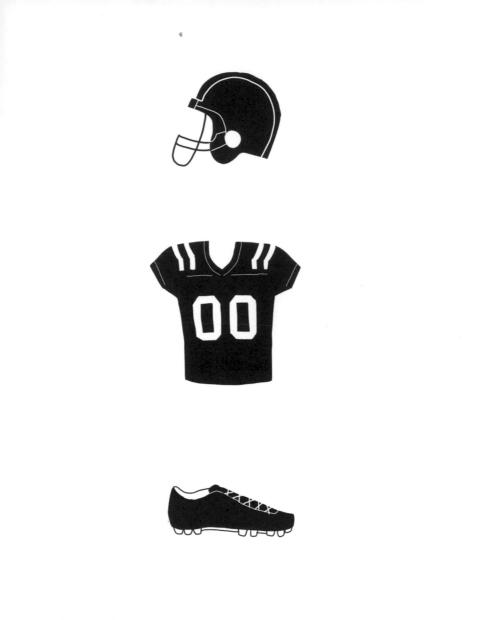

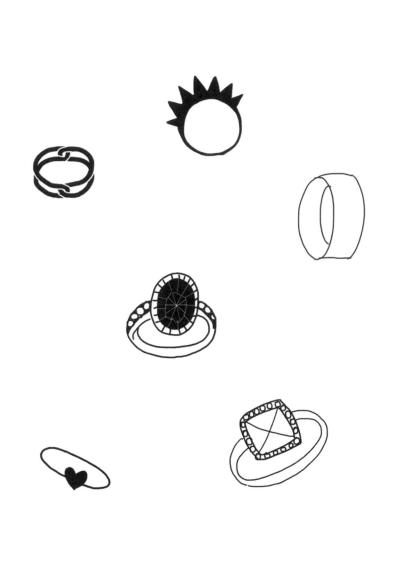

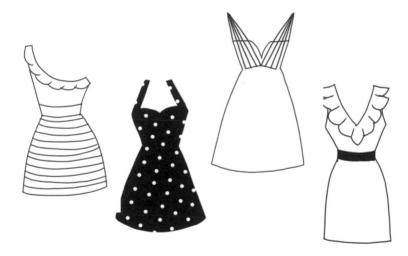

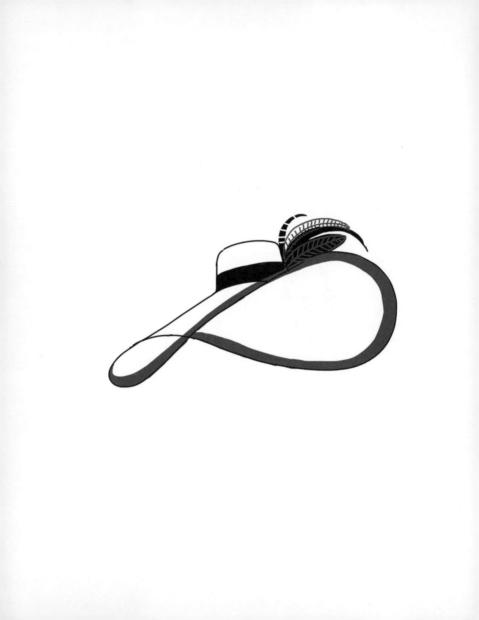

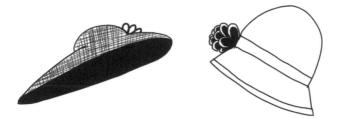

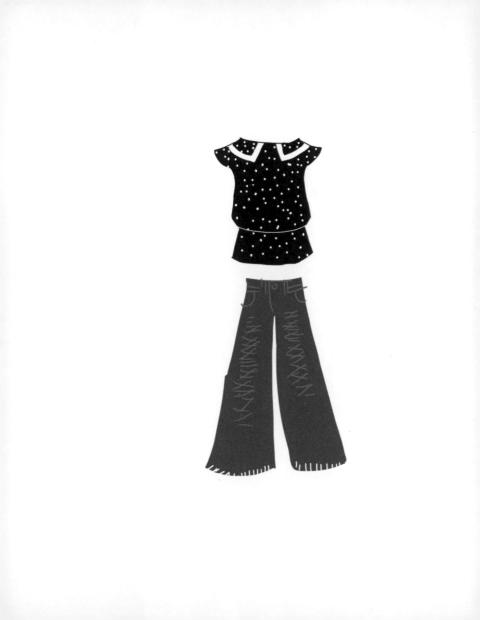

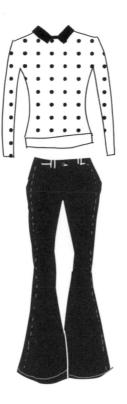

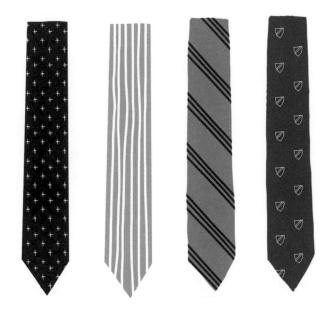

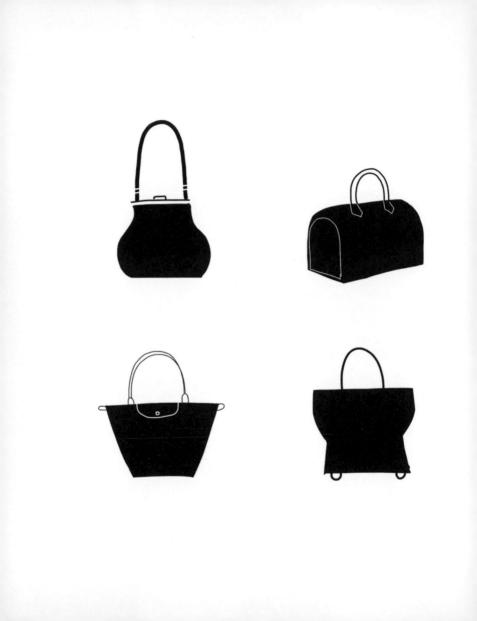

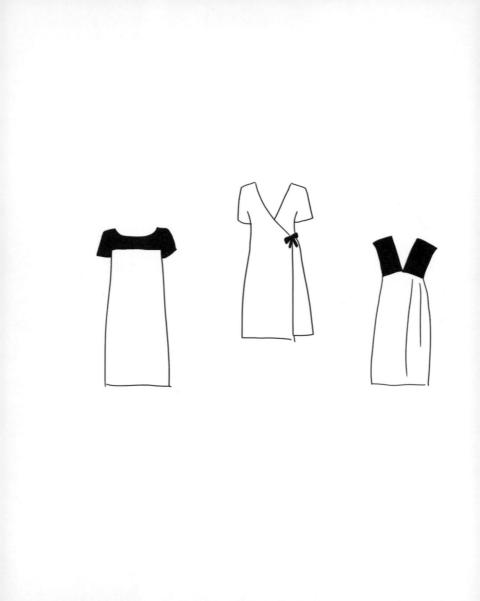

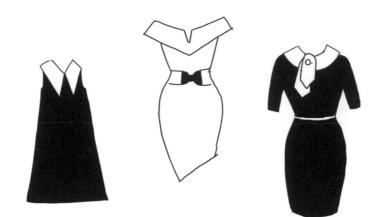

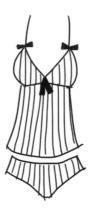

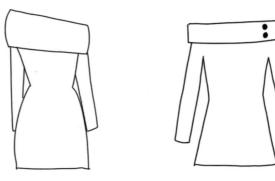

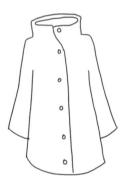

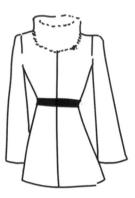

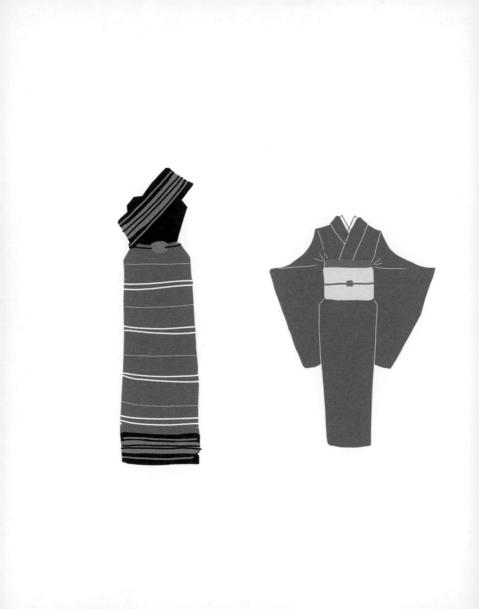

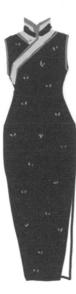

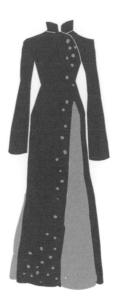

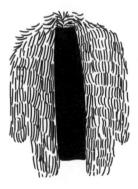

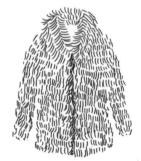

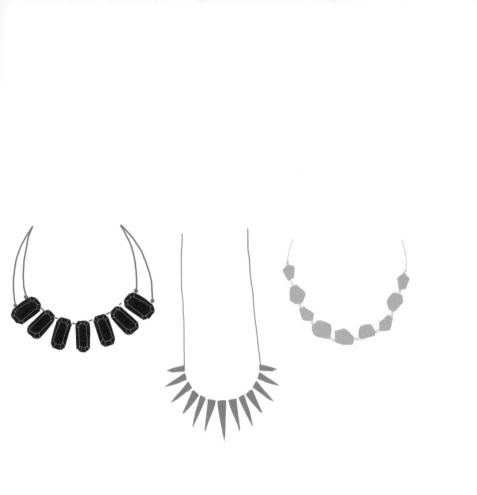

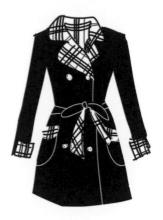

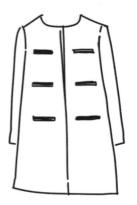

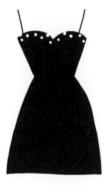

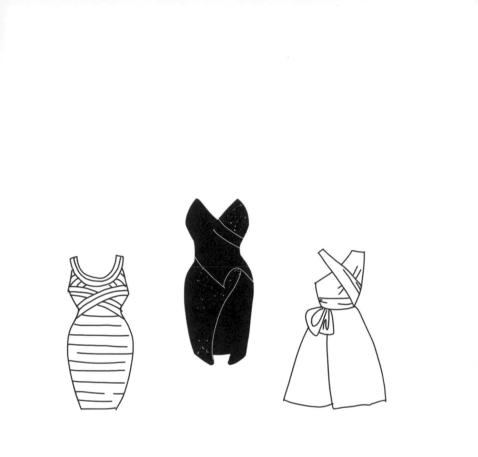

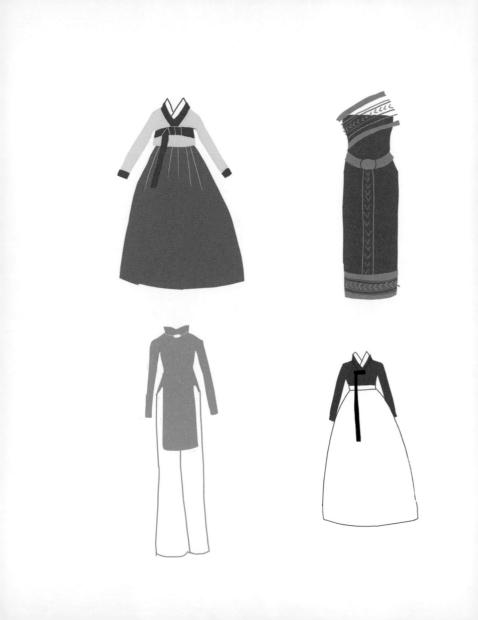

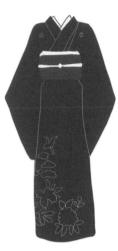

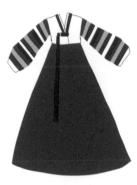

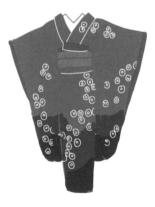

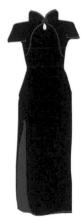

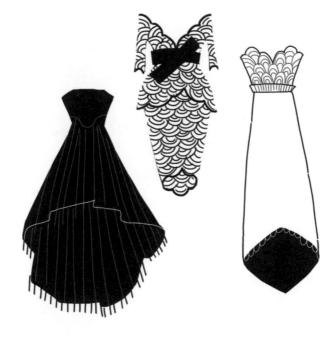

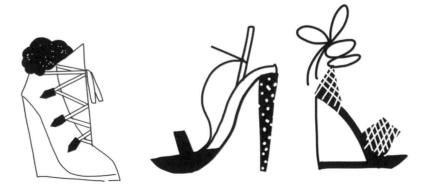

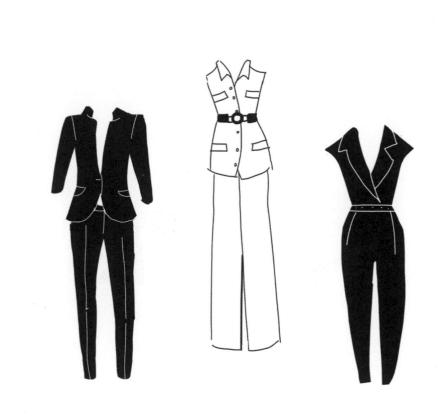

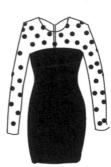

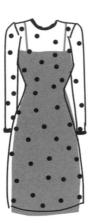

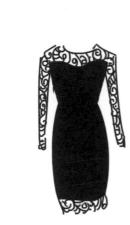

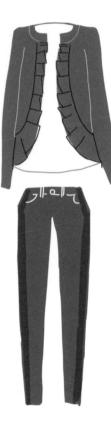

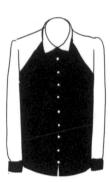

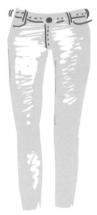

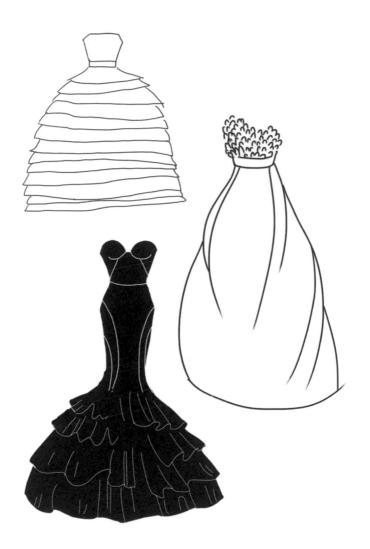

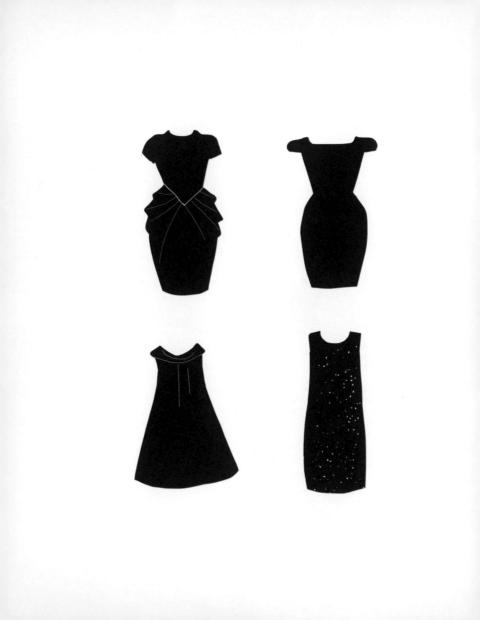

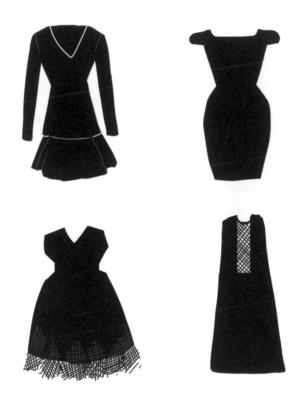

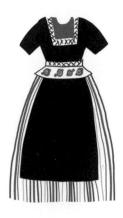

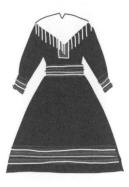

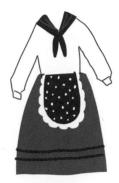

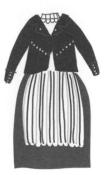

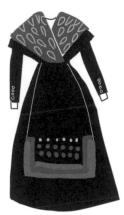

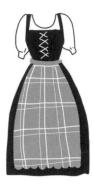

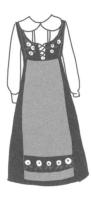

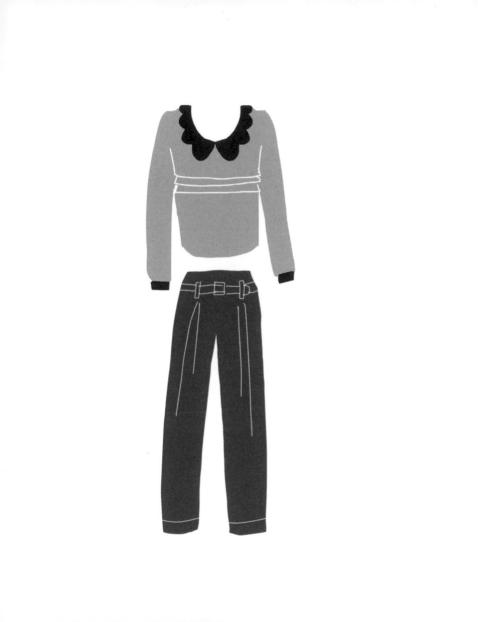

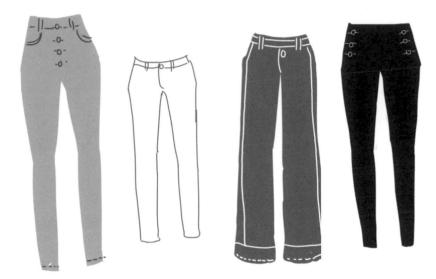

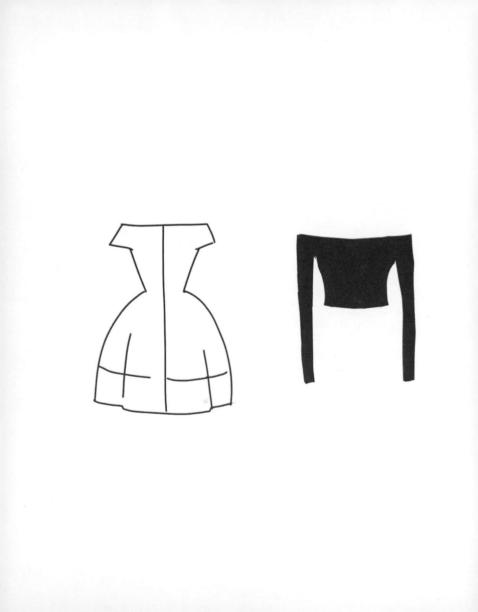

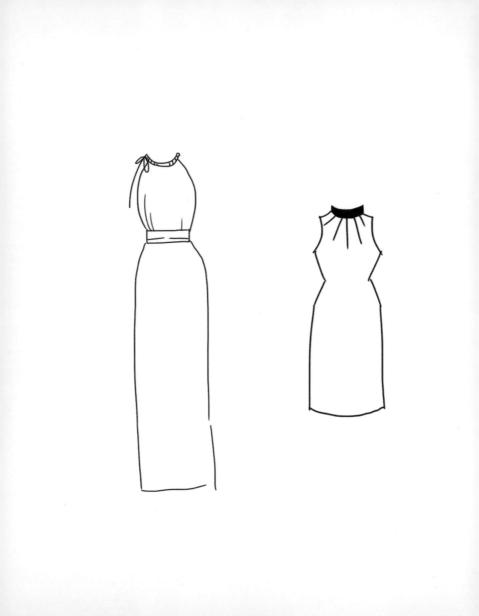

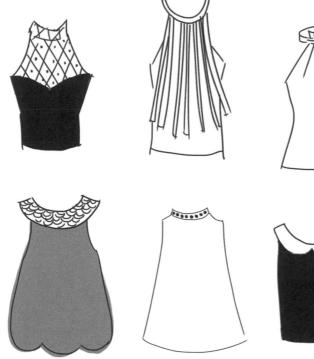

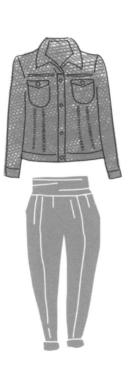

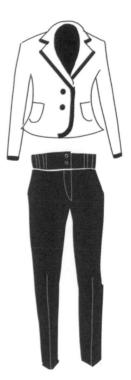

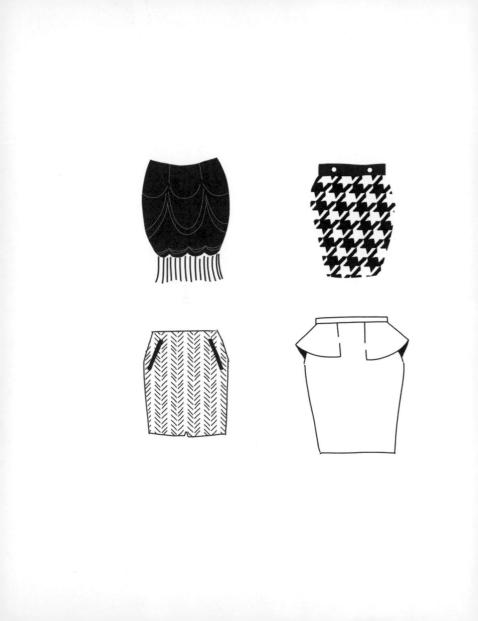

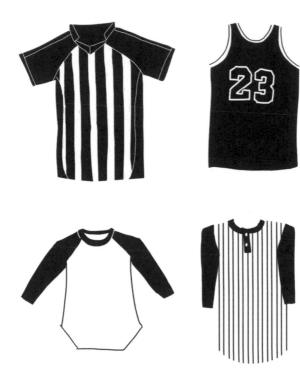

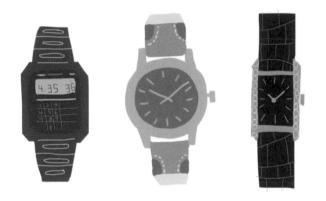

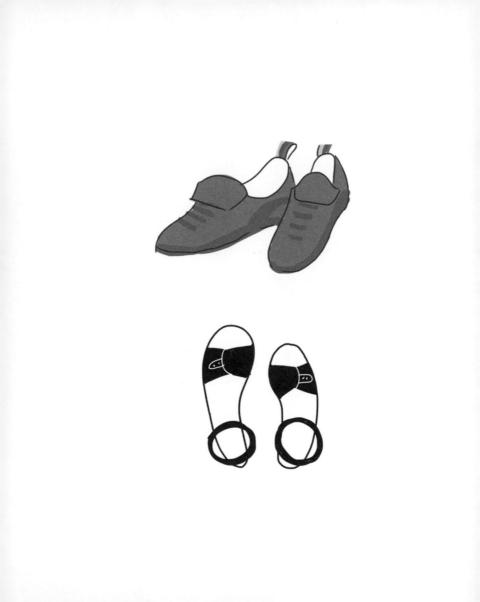

ABOUT THE ARTIST

Julia Kuo grew up in Los Angeles, California, and studied illustration and marketing at Washington University in St. Louis. She currently works as a freelance illustrator in Chicago for most of the year and in Taipei, Taiwan, during the winter. Julia designs stationery and illustrates children's books, concert posters, and CD covers. Her clients include American Greetings, the *New York Times*, Little, Brown and Company, Simon and Schuster, Capitol Records, and Universal Music Group. Julia is part of The Nimbus Factory, a collective of two designers and two illustrators specializing in paper goods. Her illustrations have been honored in *American Illustration, CMYK* magazine, and *Creative Quarterly.* She is the featured artist in *20 Ways to Draw a Dress and 44 Other Fabulous Fashions and Accessories, 20 Ways to Draw a Cat and 44 Other Awesome Animals*, Quarry Books, 2013. See more of her work at juliakuo.com. © 2014 by Quarry Books Illustrations © 2013 Julia Kuo

First published in the United States of America in 2014 by Quarry Books, a member of Quarto Publishing Group USA Inc. 100 Cummings Center Suite 406-L Beverly, Massachusetts 01915-6101 Telephone: (978) 282-9590 Fax: (978) 283-2742 www.quarrybooks.com Visit www.Craftside.Typepad.com for a behind-the-scenes peek at our crafty world!

All rights reserved. No part of this book may be reproduced in any form without written permission of the copyright owners. All images in this book have been reproduced with the knowledge and prior consent of the artists concerned, and no responsibility is accepted by the producer, publisher, or printer for any infringement of copyright or otherwise, arising from the contents of this publication. Every effort has been made to ensure that credits accurately comply with information supplied. We apologize for any inaccuracies that may have occurred and will resolve inaccurate or missing information in a subsequent reprinting of the book.

10 9 8 7 6 5 4 3 2 1

ISBN: 978-1-59253-992-5

All artwork compiled from *20 Ways to Draw a Dress and 44 Other Fabulous Fashions and Accessories*, Quarry Books, 2013

Design: Debbie Berne

Printed in China